MW01278099

Self-Portrait of an Other

Self-Portrait of an Other

Dreams of the Island and the Old City

CEES NOOTEBOOM

TRANSLATED BY DAVID COLMER

Drawings

MAX NEUMANN

LONDON NEW YORK CALCUTTA

N ederlands
N letterenfonds
dutch foundation
for literature

Publication of this book has been made possible with financial support
from the Dutch Foundation for Literature

Seagull Books, 2011

First published in English by Seagull Books, 2011

ISBN 978 0 8574 2 011 4

British Library Cataloguing-in-Publication Data
A catalogue record for this book is available from the British Library

Printed and bound by Hyam Enterprises, Calcutta, India

Transmigration of the soul does not happen after but during a life.

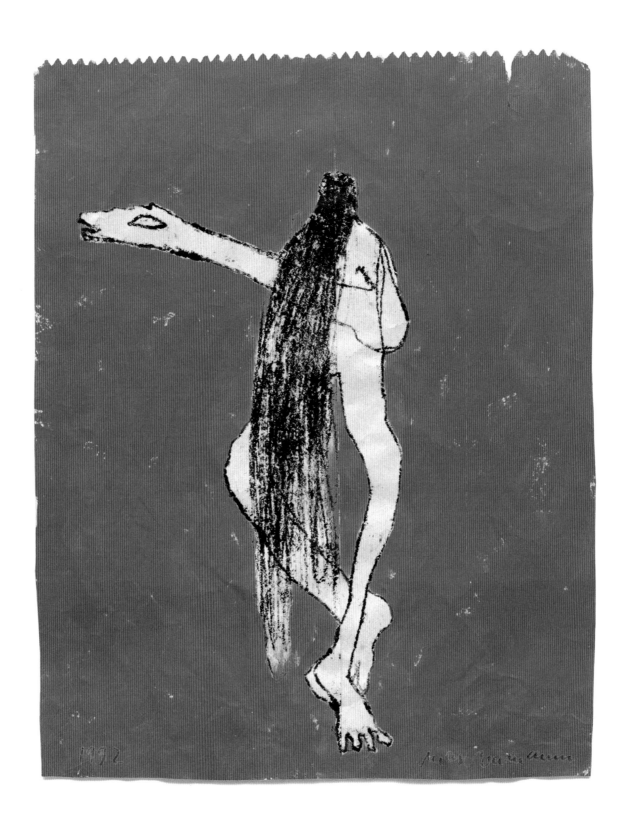

1992

I

It is late in the year. He is alone on the sheltered beach in the small bay. He had gone there to swim, the water was still warm enough. After swimming, he read. He must have fallen asleep, When he woke he realized he was no longer alone. At the other end of the beach, near the primitive boathouse with the stone ramp built to launch the ship he has never seen, an old man was sitting on the rocks. In his hand he had a stick. On his feet, worn-out sandals with tattered, drooping wings. His chest was bare, you could see how strong he used to be. Now his skin was shrivelled and as dry as a lizard's; it could not be pleasant to touch. The hair under his helmet-like hat was matted, dirty and grey. This was the first time the swimmer had seen an immortal. He kept still and hoped the god would not notice him. The protector of travellers was tired. With difficulty, he bent down to the water washing against the rocks and rubbed some on his face. He looked out to sea for a while, then stood and walked slowly to the path that follows the coast to the next bay. It was only later, after the swimmer too had dared to stand, that he saw the prints of sandals in the damp sand near the rocks. Alongside each one, the strange smudge of feathers.

II

When he is alone, crowds become mysterious. Among others, he no longer knows himself. Who are they? Does he recognize his own mask? Sometimes, on trains or pavements overshadowed by skyscrapers, he gives them names. He goes home with them, lies in their carnivorous beds, cooks on their filthy stoves and sleeps with their bodies, possessed by love. Later they visit him in his numbered rooms, their constantly changing faces full of tender lips, their suitcases packed with genitals and teeth. Fragile and mighty, they have left their homes to settle into his protective dreams. Winged Thrones and Powers, rulers of estranged flesh.

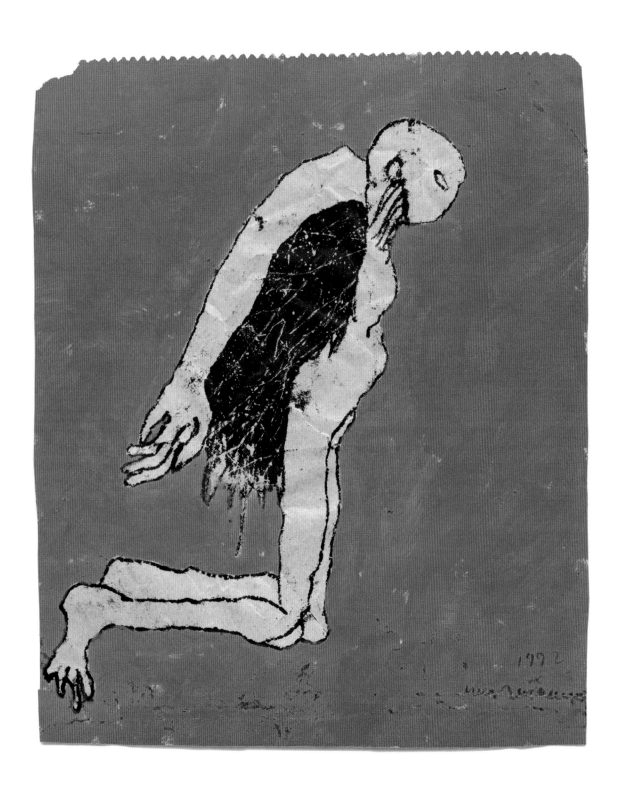

1992

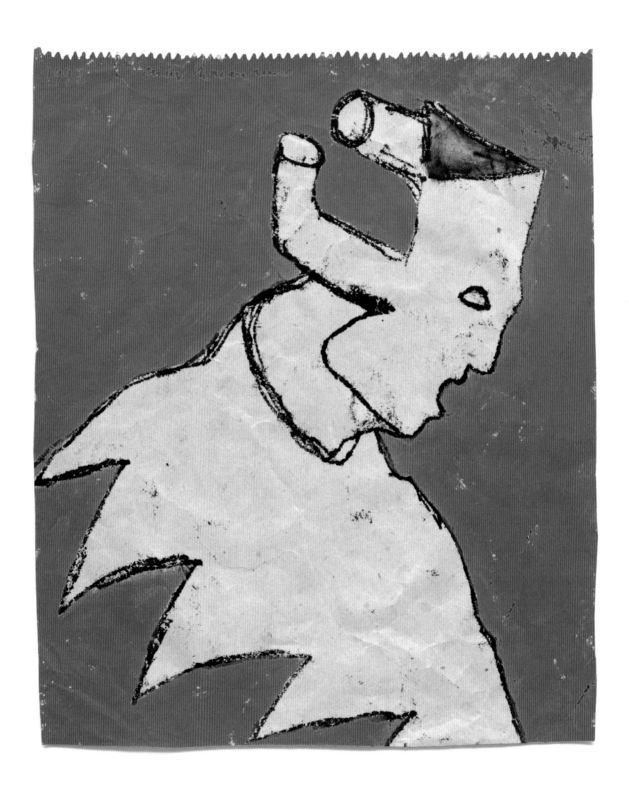

III

The building with the female head above its entrance is close to the big square with the obelisk. The city is on the other side of the island. Sometimes he drives there to look at that head. It is veiled, but not as you'd expect. The broad arch over the gate is interrupted by a rectangle that is almost too small for her. Rather than the bottom, the veil covers the top of her face. The nose is coarse, the face feminine and very round, the small full-lipped mouth is half open. The tongue inside is not visible but could emerge at any moment to quickly lick those lips; that makes it somehow voluptuous. Strangest is the absence of eyes. They are there and they are not there. The cloth, which extends halfway down the nose, is drawn to the eyeballs by some inexplicable force, its stone folds run right across them. He thinks of her as blind, but the cloth that is not a blindfold makes it impossible to tell. The longer he looks at her, the more enigmatic she becomes. If she spoke, it would be in his language. Every time he leaves her, he feels that he has failed.

IV

The wind must have changed direction while he was lying on the black rocks dreaming. The water now smells old, tainted. He looks at the Arab watchtower directly above him and thinks that from there he must have looked like a statue of a dead knight on a medieval tombstone. There is plastic floating over the cathedral he swam through with the other fish just an hour ago, jellyfish, black seaweed, ash-grey scum. The lofty space below was bright and quiet. Weightless, he swam between the swaying grasses, making his eternal circuit past the high walls with the butterfly plants. The others he encountered averted their eyes, silent and restrained. Sometimes they swam in schools: silver clouds that turned away from him in a single flashing movement as if he were a leper. Later, where you would find the altar in a terrestrial church, he saw a large fish, the head of a harpoon still buried in its scaly body. He had turned to swim by a second time and could still see it before him: the white lips moving gently, the trail of bloody slime, the perfectly circular eye watching him, as merciless as a target and with the black pupil as the bull.

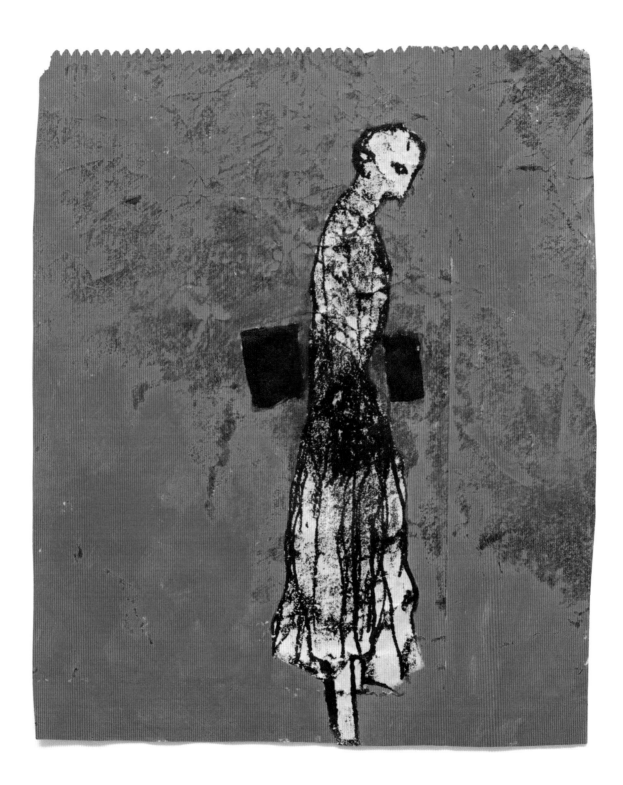

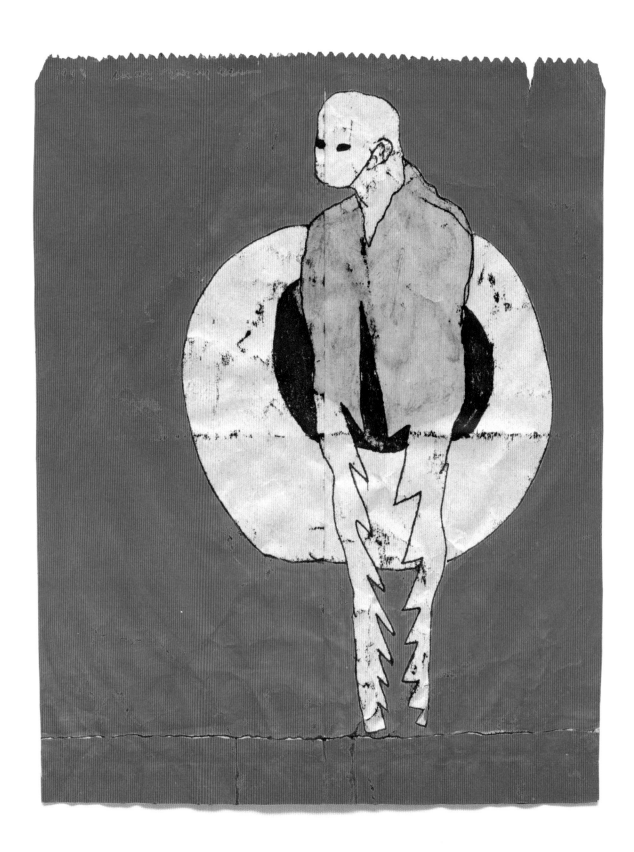

V

All day he had walked through the sweating city, going in and out of the under-ground like a mole, blinking and blinded by the light every time he came back up. He had no purpose: choosing stations at random, streets with high and low num-bers, squares in forgotten neighbourhoods, shabby parks with vandalized swings. Everywhere he went he was surrounded by new people, saving the endless series of faces for later, when he will be alone again. He followed a woman with a dog that didn't belong in a city. When they were about to disappear behind a weathered front door, the dog looked back at him for a long time. It was not the kind of look a dog is supposed to give a human being. That too was something to save. As the day proceeded, he saw the faces change, growing less and less recognizable. He wondered if his was like that too, but he didn't dare touch it and avoided his glance in the windows. Ascending for the last time in the distorting night, he hears them following him, how close they already are. The quiet clicking of their nails sounds like a watch that keeps running faster.

VI

The knife he took diving is lying next to him on the hot rock, a thing. Through his mask he saw a school of green fish that moved like a single body. In the liquid twilight he tried to pry the crown of thorns off a sea urchin, he followed the lost, drifting soul of a jellyfish. Now, naked on the rock, he sits in the sunlight like a living part of the sun itself, a body of fire. And still he has questions. How can it be that the bottom of the water surface, although no different to the top, is so much more mysterious than the restless plain he now sees? It was shining, as transparent as the glassy living jellyfish, a spreading dancing crystal that separated the domain of water from the domain of air. How easy, he thought, to disappear, becoming someone who has left his clothes on the rocks and entered the mirror forever, the impossibly thin, living mirror that seals the silence. Rid of the word he had to be, his furthest destination infinitely close at hand among the ever-silent fish, delivered from his name.

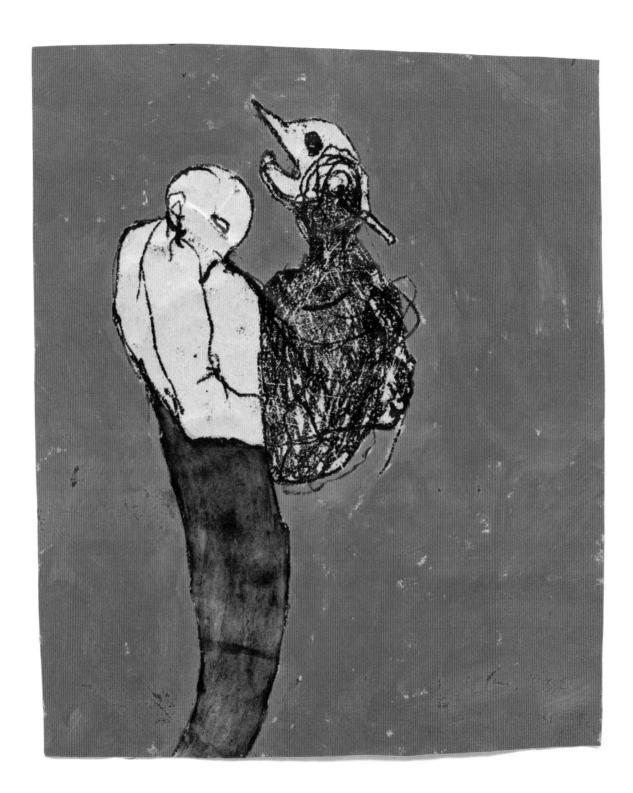

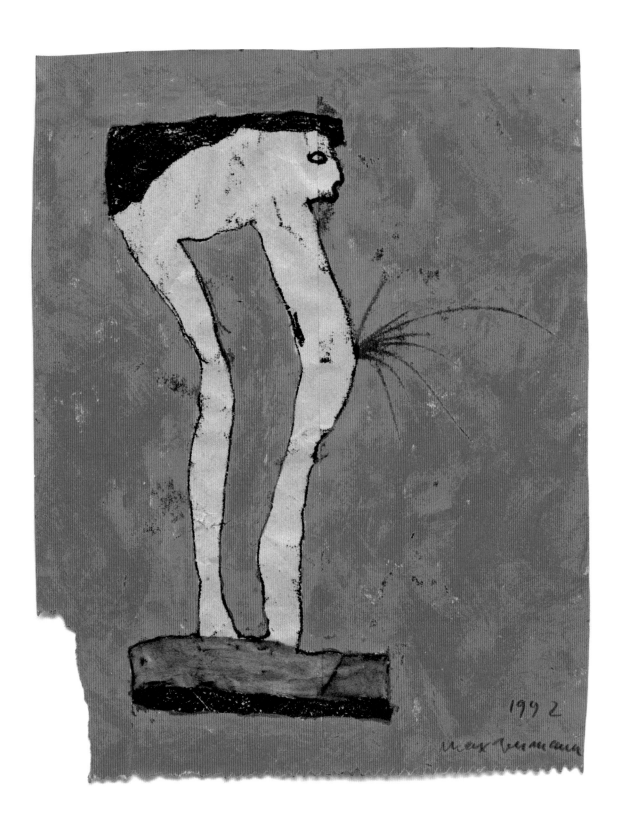

199 2

max beemann

VII

He stood at the open window of a train and it was war. Later, all he remembered of that journey was the goodbye, not who from. People on the platform, the dusky height of the arched roof, his mother perhaps in an unforgivable hat. The children on the train waved paper flags. The picture has now turned black and white, the black of crows, not the white of snow. The landscapes he must have seen have been erased, like his thoughts and the words he may or may not have said. All that's left is a girl whose face has disappeared. She squatted in a hostile, hillside meadow and pissed with her legs spread, her child's body turned towards him. The eye between her legs moved, looking at him from behind its arc of water. Fear never rusts. Later in life he often passed through that railway station. A yellow-haired girl in a corner, her back to him, a needle in her arm. An African with ochre eyes, his black skin turned grey. A man in rags, crucified on the marble floor. He thinks of the sound of the train engines, the white steam engulfing the faces. There must still be photos with him in them, photos in which he didn't want to see himself. The number of lives in an old body is unbearable.

VIII

He floats on the song that keeps repeating itself, a seduction that is never fulfilled, leaving him dangling on the edge of the sirens' territory. Unable to advance or fall back, he turns circles in the space left him, screaming his discomfort in the scorched air. He can see everything: the rat in the thistles, the burning bush, his shadow's chain gang. His longing separates him from their calls; he hears voices, not words. The angle of his wings is his only freedom. When their song grows louder, he makes a quick upward movement to identify their hiding place. Then the voices tail off again, retreating to the coast and the water where he cannot follow them. The evening breaks the spell. He flies back through the silky mist to his sleeping place. In shabby dreams, the song stalks through his restlessness: hours, psalms from a secret convent. At first light he hears their first calls. He takes wing to hunt the prey that is himself.

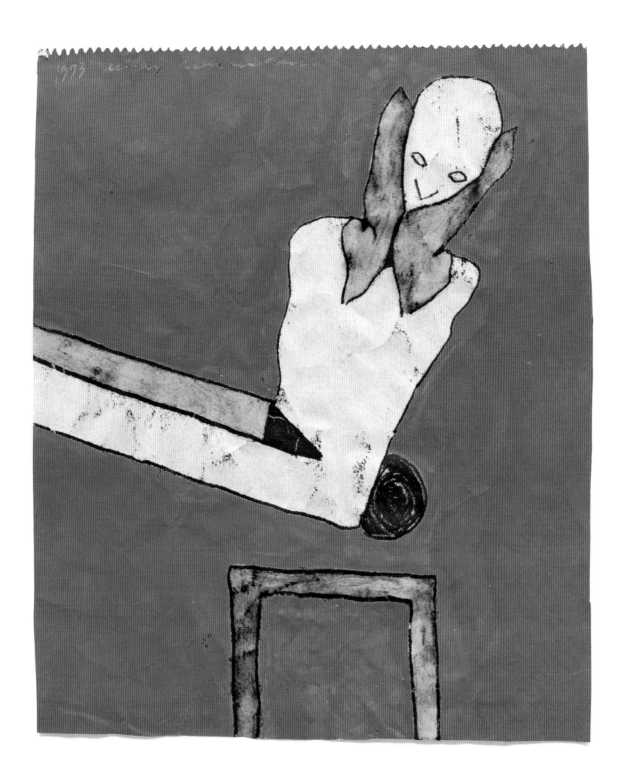

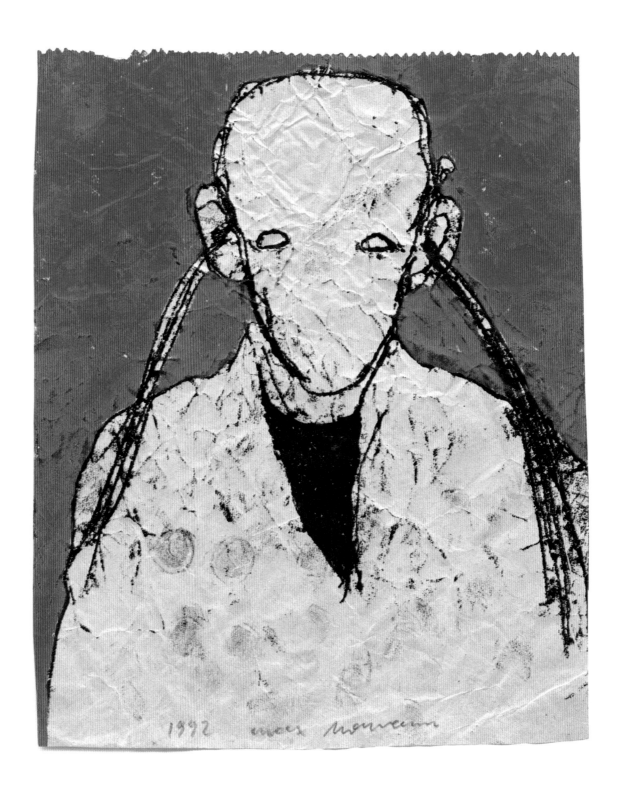

1992

IX

Walking between the dirty river and the edge of the forest, he saw his neglected body. It had closed its eyes and was wearing worn shoes. He would have liked to go up to it and touch it, but that wasn't possible. He thought of the woman in the jungle who had leant over a rusty iron drum to wash herself, the black woman who had dictated the lies she wanted him to write to her father, the mitred man in the open coffin, the murdered man on the pavement with the wages of treachery stuffed in his mouth. Suddenly he heard how quiet it had become. He didn't know if his body had recognized him. It was now walking towards the river, as if to avoid something. He closed his eyes and let the procession pass by. He too was surprised by how many dead they had known.

X

That morning he had woven himself a mask of green ferns. Now it had turned brittle and dry, poor armour he could no longer hide behind. Like spearheads the birds dived into the surging waves. He remembered falling faster and faster, the water surrounding his body like writing. He had lain like that for hours. Whether it was true that this was the origin of the island, he couldn't say. He only recalled the sluggishness once he had stopped falling, the absolution from the violence that had delivered him, the embrace of the sea.

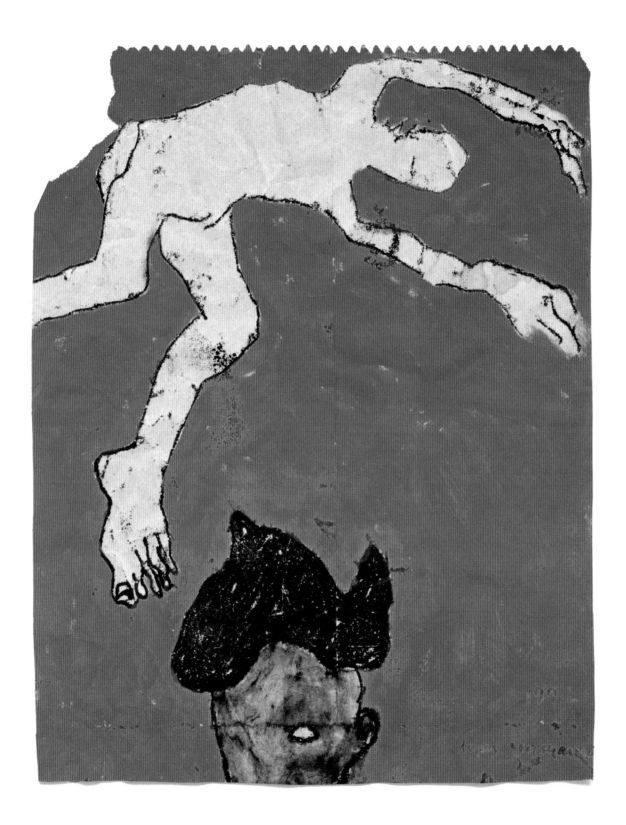

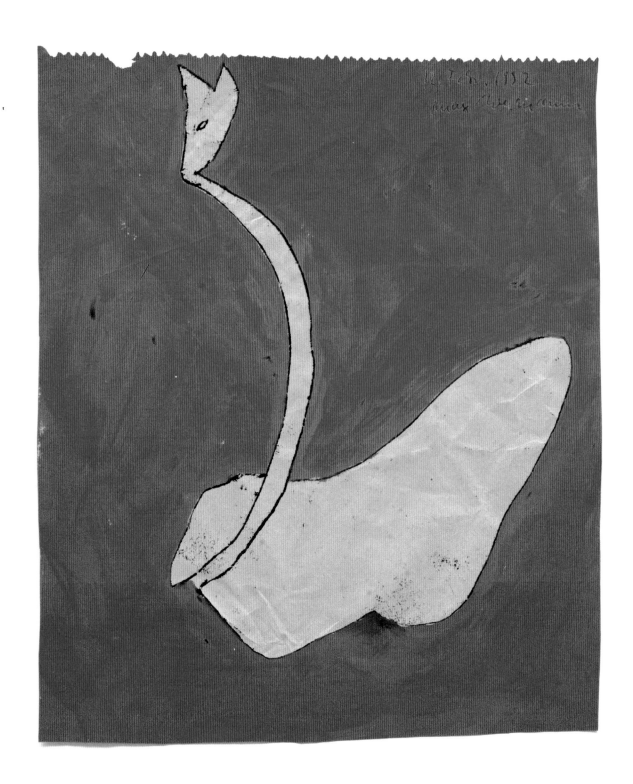

XI

He preferred being in the falcon field. To get there he had to cross the field with the apples of Sodom. The path between the stones was red and dusty in summer. The bushes, with their angular branches, came up to his waist. The apples themselves did not resemble apples, they were small and bright green, he could feel how poisonous they were just by looking at them. Later they would shrivel, wither and turn black. You could use the dried flesh to make a fatal draught. The next field was the fig field, because of the big fig in the middle with a low stone wall around it. The air there was sweet. In the hottest month you could pick the purple figs from the overhanging branches. The falcon field was further still. There was ash on the dirt floor of the dilapidated lean-to. Someone had made a fire in a hole in the ground. The lean-to had been built against the cliff on which the pair of falcons nested, he often heard their high-pitched shrieks. Now that the sun was setting, he could see his shadow on the blackened slate. Ink on ink, the absence of self as long as he didn't move.

XII

You got there by hiking up a long road in the blistering heat. Brambles on both sides, a buzzard in its own circles. Then you had to climb over an olive-wood gate that was permanently locked and pass between the outbuildings of a large farm. He expected the dog he was afraid of to start barking, but it didn't. A bare-chested man on a ladder was whitewashing a wall, so white you had to close your eyes to block it out. He asked where the burial sites were and, without turning, the man pointed him in the right direction. Now he walked past empty stables smelling of straw and came back out on a path. He saw the sea in the distance and then, almost immediately afterwards, the two stones: larger than a man, one dug into the ground and standing upright, the other laid horizontally on top of it. A ring of smaller, much rougher stones had been placed around the monument. He felt the change when he stepped into the circle. Now there was nothing except silence, the forms it adopted in this place. He sat down and thought about the people who lived here thousands of years ago. What were their voices like? No one came this way. The countryside could not have changed. The wind rustled through the holly oaks, making it sound as if someone wanted to say something after all. He laid his hand on the lower stone—a different, broader hand than the one with which he had written that morning—and remembered the name of the man he had buried not far from here, the sorrow, and the word that had existed for it. That night he dreamt of a building he had never seen, a man in a blinding haze of light who kept his face hidden.

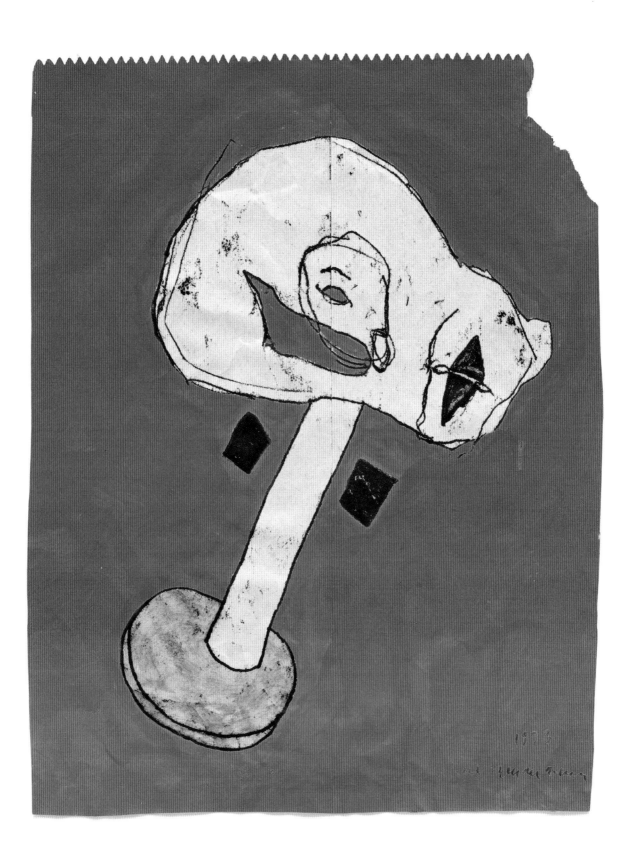

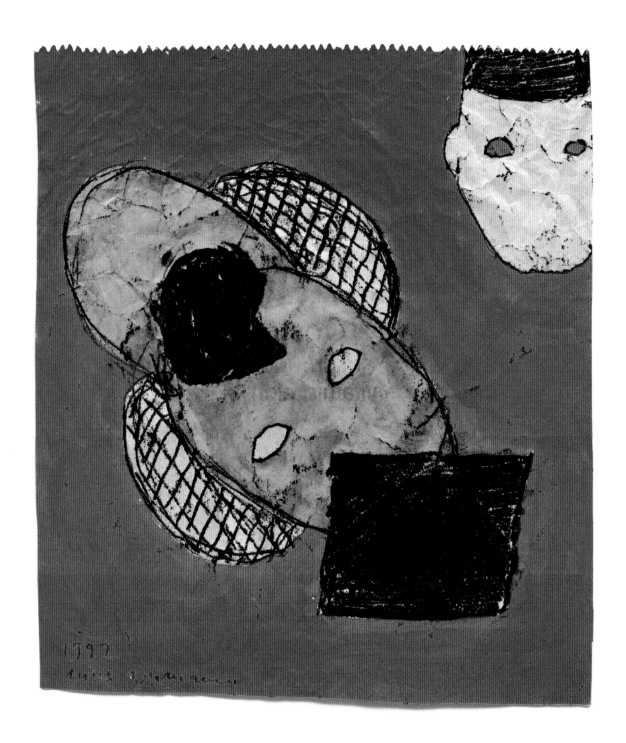

XIII

He saw the woman on the street and went with her. Stairs, a humiliated home. The woman is young, a child of the desert. They are both strangers in this city, linked by exile, exclusion. Lust is the pretext. The rest is still there, a rumour from person to person. She kneels on the bed so that he can no longer see her face and extends her arm to the purple opening in which he must disappear. They hardly speak, and not in their own languages. A woman from a landscape of sand, who can put her thirst aside. You turn the stranger into a dog or a dead man. You keep your face to yourself and remain blind to his. Of all love's forms, that between strangers is the most mysterious and the most convincing. They give each other back to the city in which they must disappear.

XIV

The ants had eaten away at the rhinoceros beetle for a whole week, but the shell was still intact, a gleaming black basilica. He wondered why they kept going in and out. The horn was gone, there were holes where the eyes had been. He had seen faces like that in big cities, in the evenings when the offices closed and swarms streamed out on their way to distant homes. It was as if they were all stuck together, gigantic beetles with gnawed-down, hollowed-out faces, reading newspapers and disappearing under the ground on invisible trains. Their conversations were about the plague and the cancer of ants, the sudden worthlessness of money.

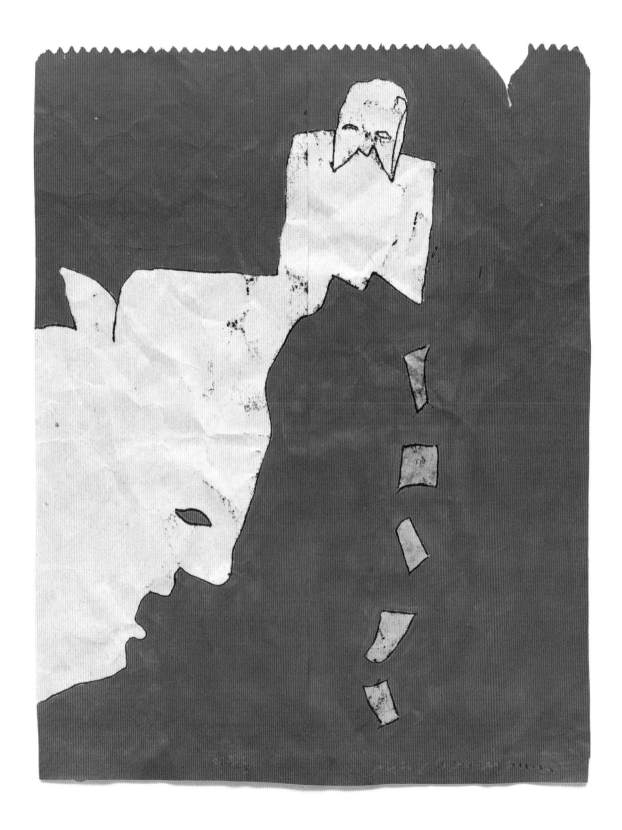

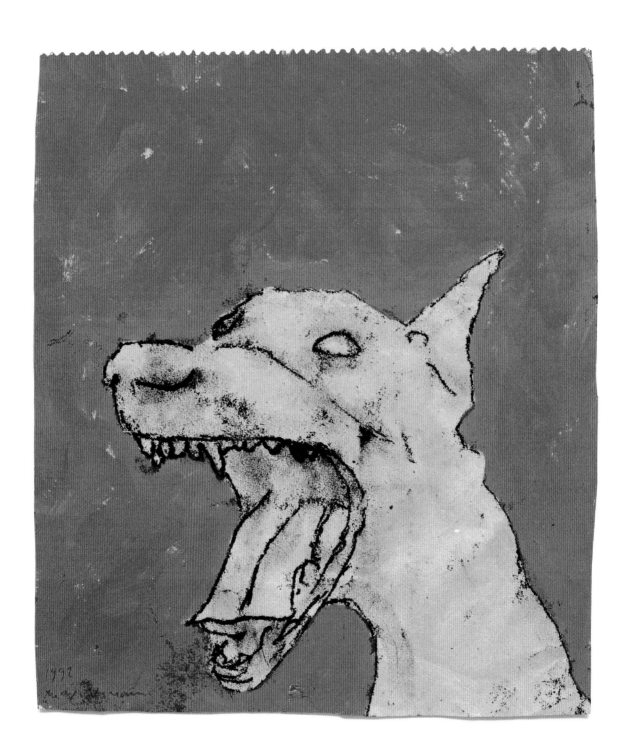

XV

'Without,' he said the word quietly to himself, 'without'. He sketched the enormous wing of mountains around him. Would anyone ever know what they concealed? The tracks of deer, the spider webs, the music of weaving, the taut string that sings louder and louder as the victim dies, the slow binding of transparent wings, as if bandaging them so they might heal. Death as a gentle wrapping, the antlers at the foot of the tree, dew on the web that constricts a carcass. No more rutting calls, no more biting weasels, a prey no more. The drained cadaver deprived of its flight, the fading mantles left behind in the grass, banished from the cold heights of one's brief life, one's protracted death.

XVI

Now it approached him, the dog that usually walked straight through him. The afternoon burnt like straw, he longed for the river and the soft-voiced boats. He knew that his continued existence was due solely to his addiction to thought, the chains of words he draped over things that remained unnameable despite their names. It had been a long time since anyone had touched him. He couldn't do it either. His body did not seem to exist. When he searched for it, it was always somewhere else.

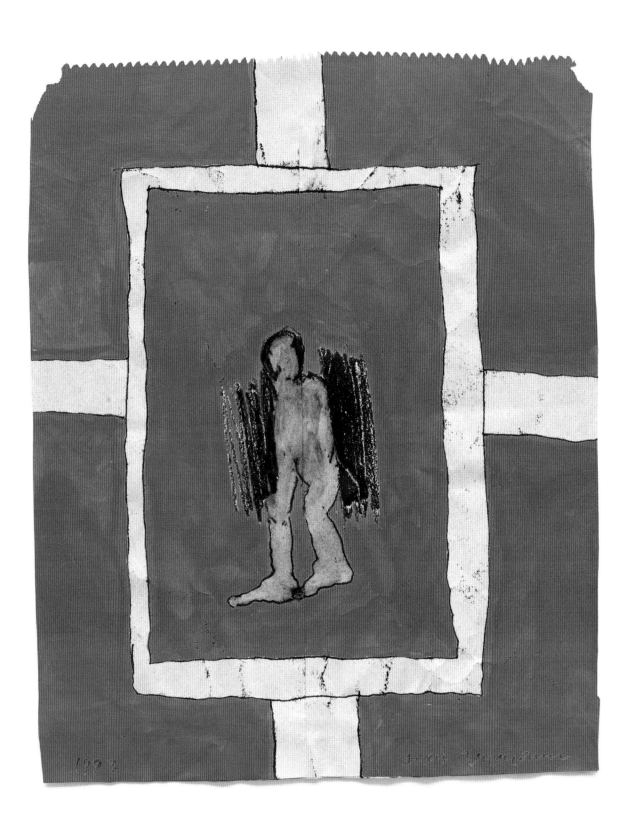

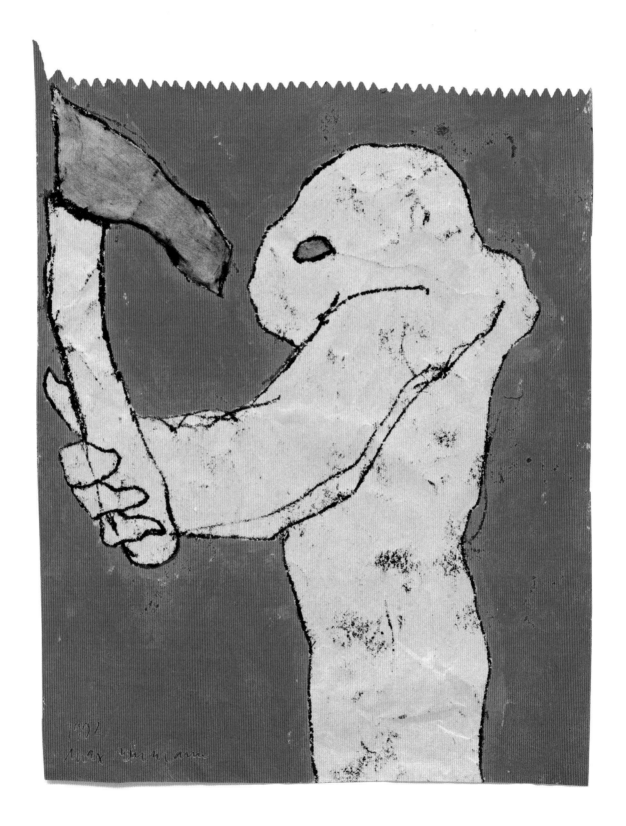

XVII

In a field of rocks and thistles he saw the father he hadn't seen for more than half a century. He was wearing a sinister uniform flecked with mould, in his hand he held a revolver. He didn't want the man to recognize him and turned his face, but when he looked back his father was sitting on the pavement, naked and covered with sores. Now he wanted to go up to him, but the look the old man gave him was so terrified that he recoiled. The ribs were visible under the grey skin that had taken on a cold sheen in the rain, his penis lay on the wet paving stones like a large worm someone had squashed underfoot. It was clear that his father was close to death. When he looked back once again from a distance, he saw a circle of men and women standing around him. In the field with thistles the man with the revolver was still waiting.

XVIII

Someone on a country road, a silent figure, shrouded by his shadow. Then came the series: child, dog, priest, three elderly women. He couldn't do anything with that. He sat down on a rock as if to weigh the evening. Slowly it grew dark, he heard the pebbles in the stream rolling softly against each other, quietly clicking and grinding, a sound they also made in his absence. Being polished, he thought as he felt their round shapes in the palm of his hand. Later, when the mist was already hanging over the water, the night turned into an owl. He shuddered at the cry that made the silence unbearable.

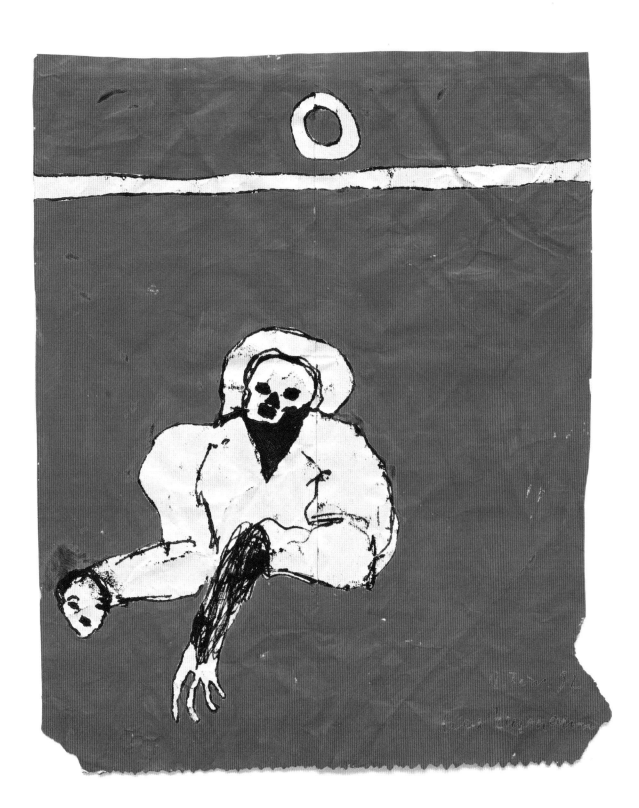

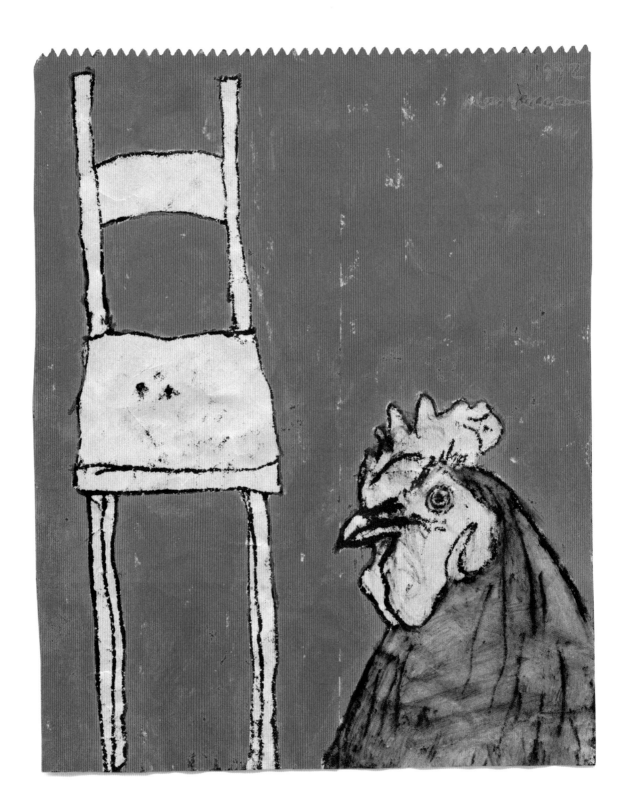

XIX

He remembered the end of the friend who should have died after him. When he approached the deathbed, the sick man didn't move, as if he was already tied in to something else forever and no longer expected anyone. His eyes were open though, he was staring out through the window without seeing anything. Only after a while did his friend turn his head towards him—slowly, searchingly. There was something very solemn about that movement. 'You, here?' he asked, as if the visitor were lost, trespassing. 'Yes,' he answered. The other's eyes, which were as dark as ever, looked at him slowly, his gaze taking much longer than usual to reach him. The late light made the thin, transparent tube running from his nose to a machine look like a piece of jewellery, something from a world the other would never enter. Then the man in the bed smiled—equally slowly—and said, 'You're the last person I will ever see.' After that, neither of them spoke again.

XX

Autumn brought the rains to the island. Driving home one night he sees thousands of snails crossing the road as if it has been repaved, badly, with living porcelain. It's impossible to avoid them and the crackling under his tyres sounds like obscene whispering. Suicidal armies with him as their violent accomplice. Wanting water and finding death. At the bend in the road he sees the dishevelled old man who, for years now, has been building a ship he keeps covered with tinfoil in the middle of a field somewhere. He stands there in the headlights surrounded by rain, a mad king calling for his daughters. It looks like he's singing.

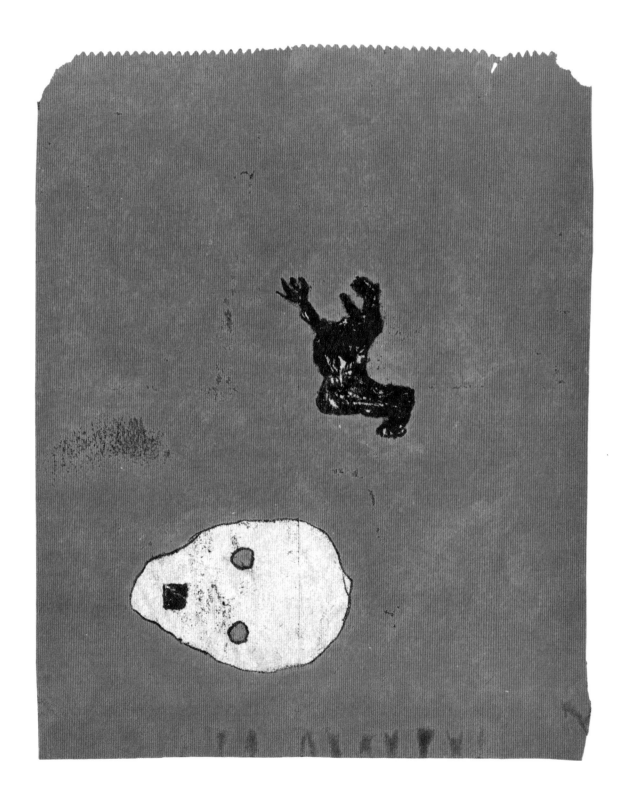

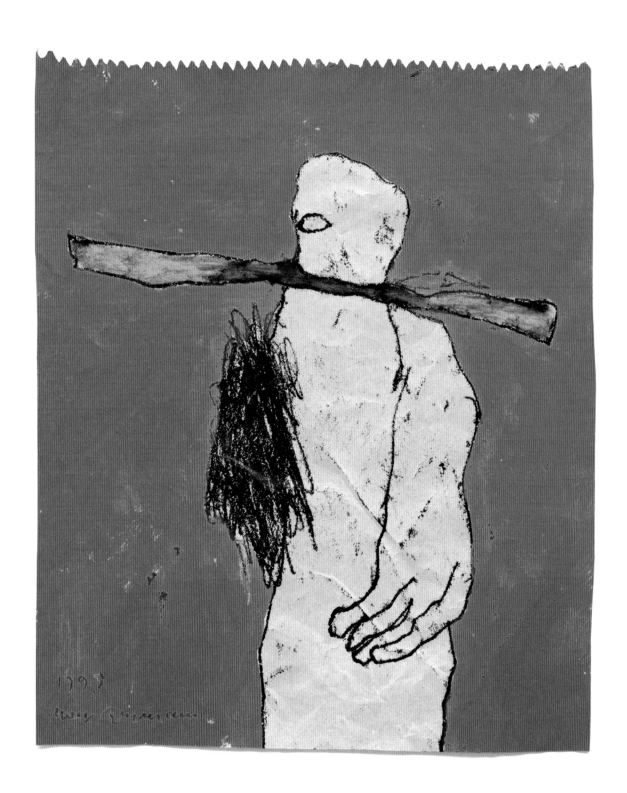

XXI

He is back in the old city, which has become the city of questions. It is spring and
he has seen himself at least a hundred times in all his former incarnations: drunk,
riven by fear, happy, in the snow on a pavement, at a graveside, in a hospital, a
brothel, a monastery, visiting friends and women who are already dead. The city
has changed and never changed, he has changed and changed again, the impossi-
ble has insinuated itself into his desires, something irretrievable accompanies him
wherever he goes. Like a shadow? A shadow accompanies him wherever he goes,
his dog-headed double, the man who knows more than he ever will. He sees the
new leaves on the chestnuts, the other, new people, the river, the cathedral, the
bridge, he sees the ghosts that surround him, an enticing procession. Soon he must
leave this city as if he will never return, a man walking hand in hand with himself.

XXII

He has taken the narrow red path that leads to the coast. There is music coming from the protective last house before the sea, music that does not sound like music and tells him something about the shape of time. Intervals, accents, rests, sonorities single and double that bend over each other, draw back, cease. Meditation, not history. No ending. The shutters of the house are closed, the piano must be near the window. Someone who lives their days at night, for whom hours do not exist. He waits, a hand on the wall of piled stone. How long he stands there he doesn't know, even he doesn't know. The music doesn't flow, but still something is being measured; in which direction is not always clear. It could be backwards like memory. The thought that the silence between the notes is calculated as time moves him. It turns the absence of sound into music, as invisible and inaudible as time itself. Audible, inaudible. In that silence he carries on until the greater silence has absorbed everything, sound and the opposite of sound. Only then has he reached the sea. Rhythm, the number of the waves, sequence.

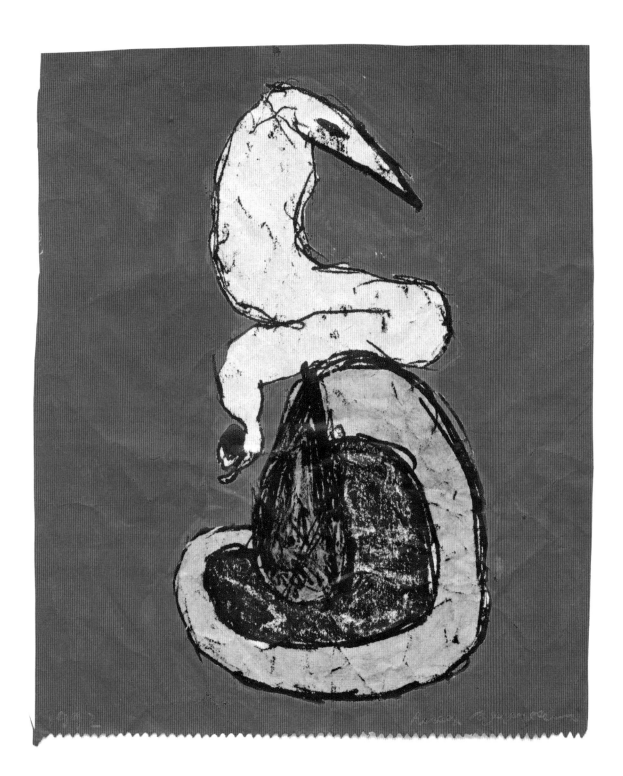

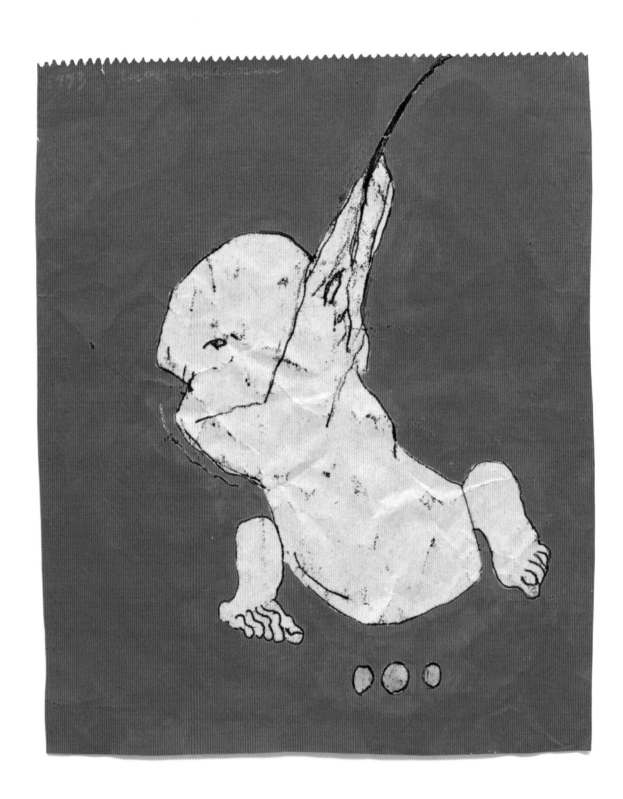

XXIII

Tonight too it is night, winter and war. He has woken to loud voices and the rare sound of a car. To see what's happening, he pushes a chair up to the window. He is not allowed to turn on the light. In the cold of that night that has never ended, he sees the gleaming black car and the boots and peaked caps of the officers who don't speak his language. The small flakes melt on the bonnet. Standing against the wall are two identical women. No matter how hard he looks, he can't see any difference between them. Their faces are white in the light of the lantern, their mouths big and red. He sees the white crystals of snow in their high, identically-styled hair, the single gesture with which they hug their big fur coats to their bodies. Without understanding, he knows that this is about fear and flight. He feels their terrible identicalness as a threat, not yet knowing that twins too can grow old. It is now almost fifty years ago. Frozen in the celluloid of their image, they have never changed. When they call out to him, he still feels betrayal.

XXIV

There was yet another form close by, another face casting his own into shadow.
His might not have existed any more, but that was unimportant. The form would
multiply, he would exist everywhere, mostly invisible. What mattered was having a
voice that almost no one could hear, requiring as few words as possible. He lay flat
on the ground, which was already cold. His mother emerged from one of his
dreams. Moving as if she had been silvered, she followed a road with bent trees.
He heard her singing. Then nothing happened for a long time. Now he needed
thoughts to replace his face, the absent shield. There were other hands too now to
take the place of his, he hardly needed them any more.

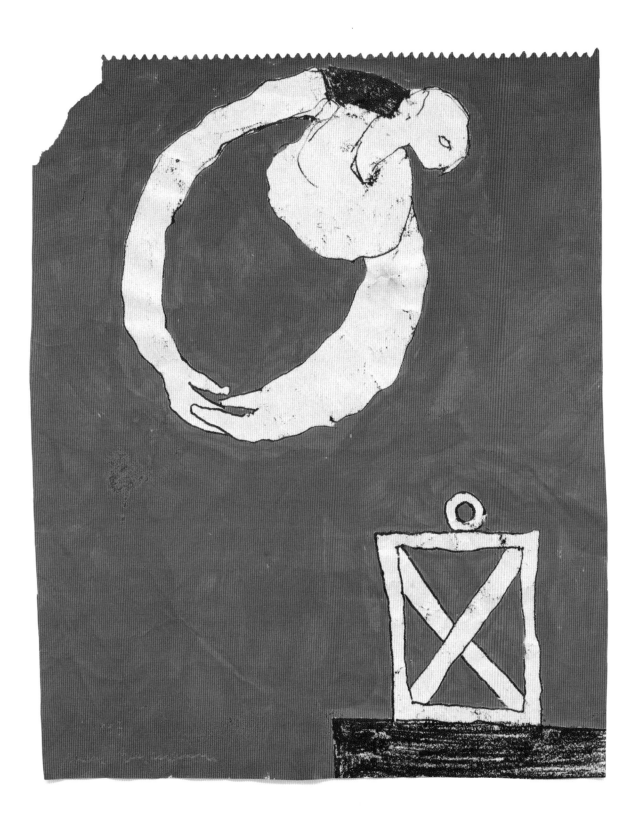

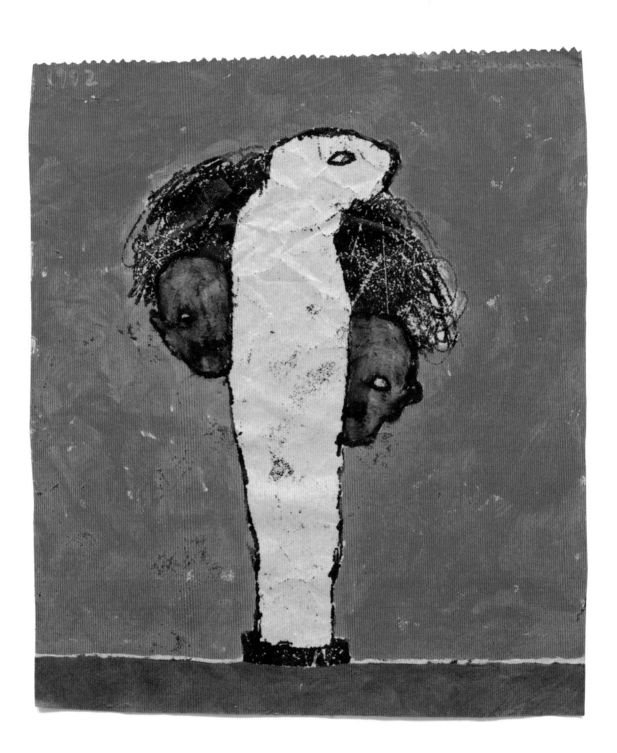

XXV

He doesn't want to see himself this unfinished again. Blood trailing from a nostril, the face of his other self. Degenerate, thin, profoundly drunk, his hair cut like a monk's, denial of depravity. Or not? He stares into the emptiness of that face. A chasm, the danger that must always be there. On a night like this he lay on a frozen pavement in this same city. The person who found him remembers it still, a corpse's face with an insane smile, hidden in the poisonous snow. Craving sewers, beds, graves, subterranean pleasures. This lesson too stays with him. Transmigration of the soul does not happen after but during a life.

XXVI

This time there were two of him. He could tolerate the sounds of the night better on his bird side. In the distance he heard a drum-like thrumming, in the sky he saw rings of fire. In the tall cliff face there were statues wrapped in cloth, their eyes closed, their stone heads covered with red and ochre mildew. He felt like lying under one of those statues and looking up at it for a long time but his other self raised him with an angry flap of its wings, shooting away from the cliff until it was over the reeds, the field of moving script.

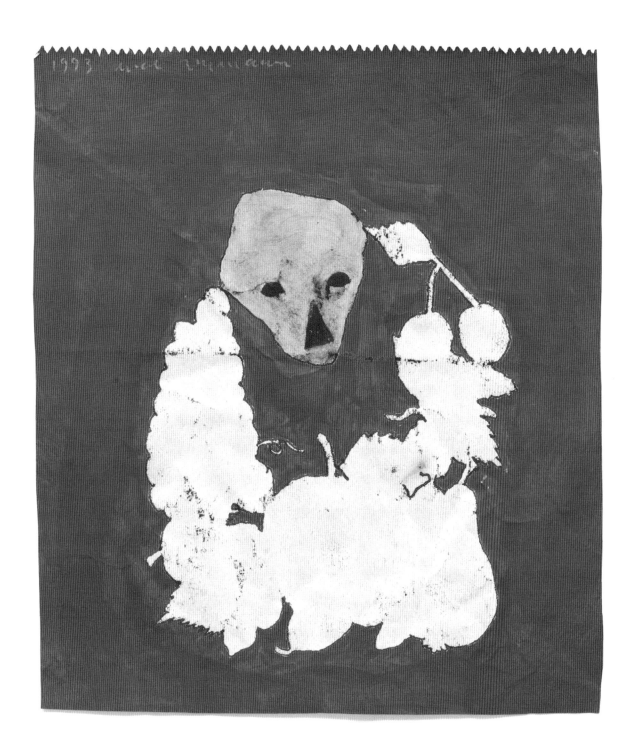

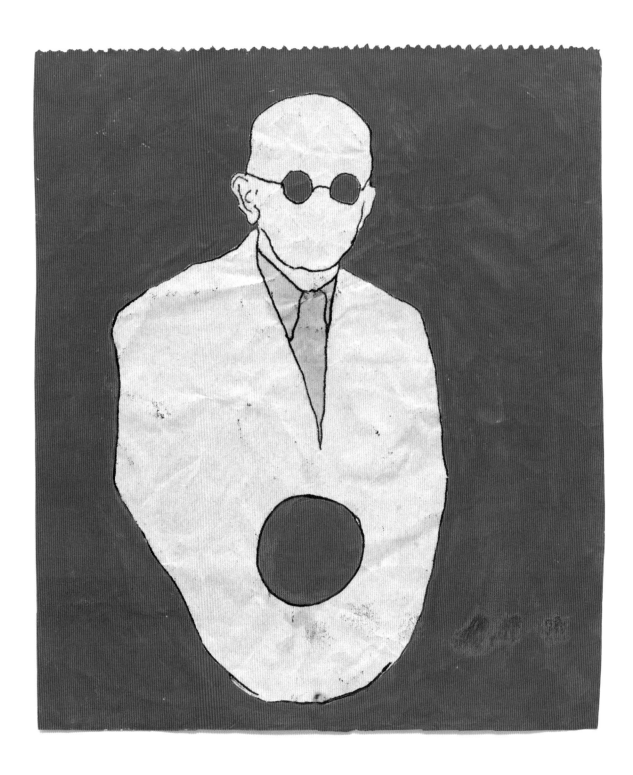

XXVII

This must be the tenth year he has passed the wreck. The ship had run onto the rocks in a winter storm, that first year it still looked like a house searching for its dead. Tilted, as if stuck on an absurd, lateral wave, with the wave itself turned to stone. No one left in the wheelhouse, the nameplate stolen. Wind and surf, the only voices. After that he had seen it deteriorate from year to year, diminishing, the battered shape of a ship. Beams were left, ribs of thick, dead wood, an inverted vault, held together by nuts and bolts made of rust. Slowly the sea would hollow out the shell until there was nothing left. He alone would recognize the last traces. It was a question of who would hold out the longest, him or the wreck. He leans on the missing rail and sees himself disappearing amid that which must remain, amid all the things that were already there.

XXVIII

Half a century ago, maybe less. He is someone else but has the same eyes. A city in the country he keeps going back to. In the vague distance, the only car. One lamppost fully visible, the other half. The square is so bright it's floating, no world beneath it. The grey of that light cannot weigh anything. A woman has crossed the square, she approaches the place where he is standing but will never see him. She is wrapped in herself as only a woman can be, hugging herself as if she might otherwise break. He cannot see her eyes, her mouth is hidden. Even now he remembers that it was cold, her overcoat flapping below the knee. Her hair was blond and, in this instant, not intended for anyone. Three men on the other side of the square stopped to stare, a couple of cyclists dismounted, but perhaps they had already done that. Nothing else happened except that he remembered it. A first lesson in absence.

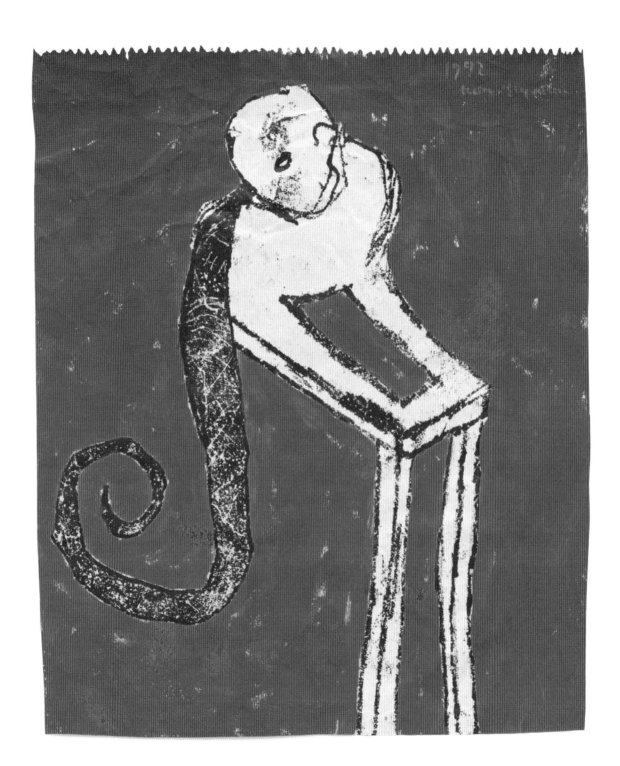

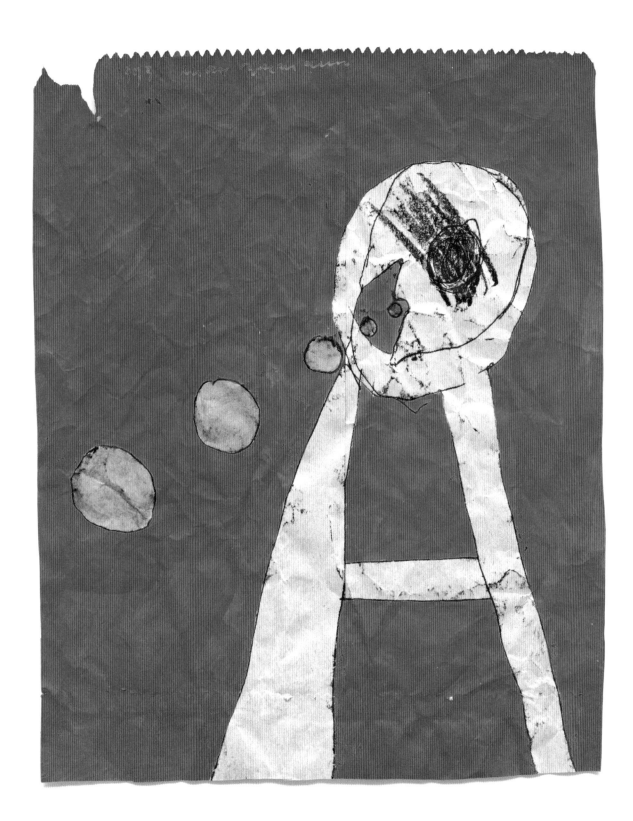

XXIX

Disappearance as a boon, estrangement's song in the earlier landscape. In darkness
still, he tugs at his ropes but not to free himself. That was what he wanted to be,
the free prisoner, who had studied the sea in his memory, its surging waters, move-
ment. The world, less and less of that. It wasn't necessary. He could do without.
With his back turned on the whispering, the voices, all the things a blind man hears
in the infinite house of his own self. A house without guests, halls, steps up and
down, his thoughts as maxims around him, always the same. Still to come: the
dream of waiting, the footfall, sleep.

XXX

He is back in the field of rocks and thistles. Now that he is blind, he sees everything more clearly. The route of the path, the tortured pine, the insoluble bushes. When he lies down, he feels the earth's current, floating off between the rocks. Nowhere is as dry as here, the water is made of leaden silk. He protects his eyes from the light of arrival. His body has become the distance he has travelled, it will not speak again. He undertook all his travels for this voluptuousness. Now that he is deaf, he hears everything more clearly. He hears the rocks like a rock hearing its own sound, time's unbreakable now.

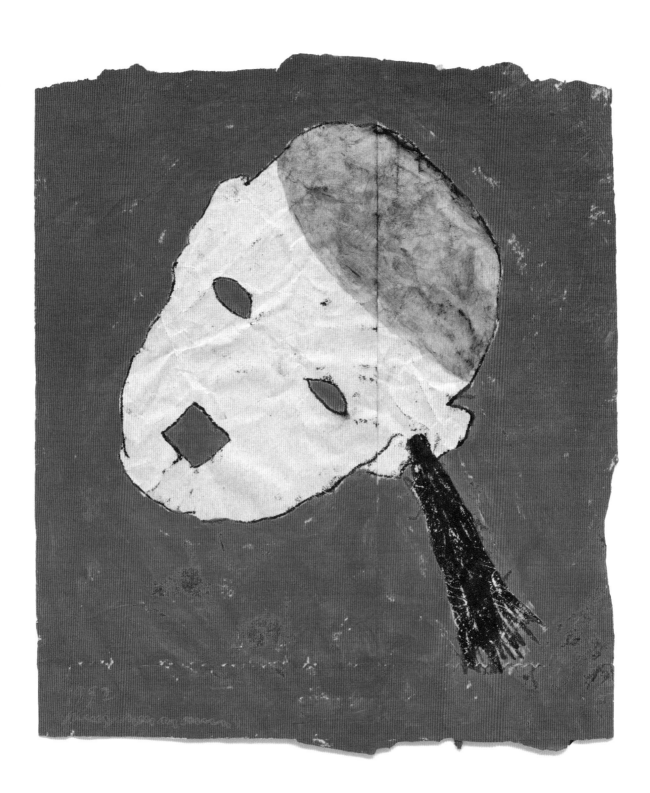

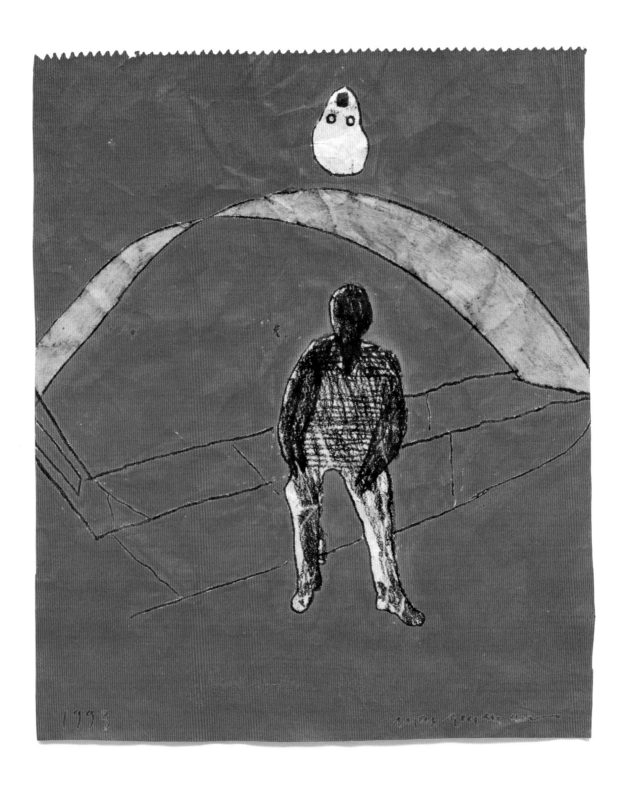

XXXI

This memory was not a dream. He was driving along a coastal road in the tropics.
It was very early in the morning, too early for traffic. Veils of mist, the heat would
come later. After he had driven a few miles, he suddenly saw a dead donkey lying
in the middle of a bend in the road with two dogs eating its insides. They were
crouched at its ruptured belly, diagonally opposite each other. He remembered
their faces buried in the intestines: during their meal they had taken on human ap-
pearance. It would not have surprised him if they had spoken to each other. He
got out and walked up to them. They had blood on their mouths. Still chewing,
they had looked at each other briefly, then shrugged their shoulders like people
who have been disturbed during dinner. That night in the travelling salesman's
hotel he had gazed intently at himself in the mirror, but the light was so dim his
face was hard to make out. He had been reduced to two eyes and a mouth, and
the pupils had almost disappeared from those eyes. He didn't look like himself.

XXXII

They had bound his head. In this darkness nothing could ever be the same again. He felt the rope's sharp strands cutting into the corners of his mouth. But he wasn't blindfolded, the dark was part of the space he now occupied, which could only be the space he himself was. Movement was completely unnecessary, he wouldn't have known where to go anyway. Days passed before he heard voices, but he couldn't prove anything.

At the end of the plain, a mob that looked like rocks. They moved towards him with their stony faces, recoiled and disappeared. Everything was now empty. His body was a snake's, elongated and the colour of sand. A hand, his own perhaps, gripped his neck, which was tight from screaming. The one without a mouth had to be there too, and whispering.

During the last days, the rains brought the desert sand with them as if the sky was weeping blood, red dust on white walls. At his feet he was a dream. That made the roads passable. There was no question of any direction. The one who constantly threatened him knew what he was doing.

That was the third face.

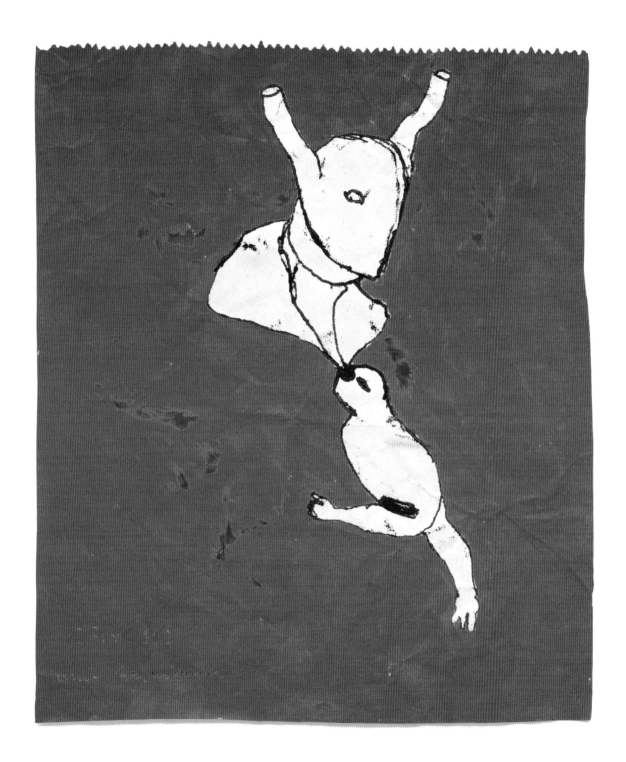

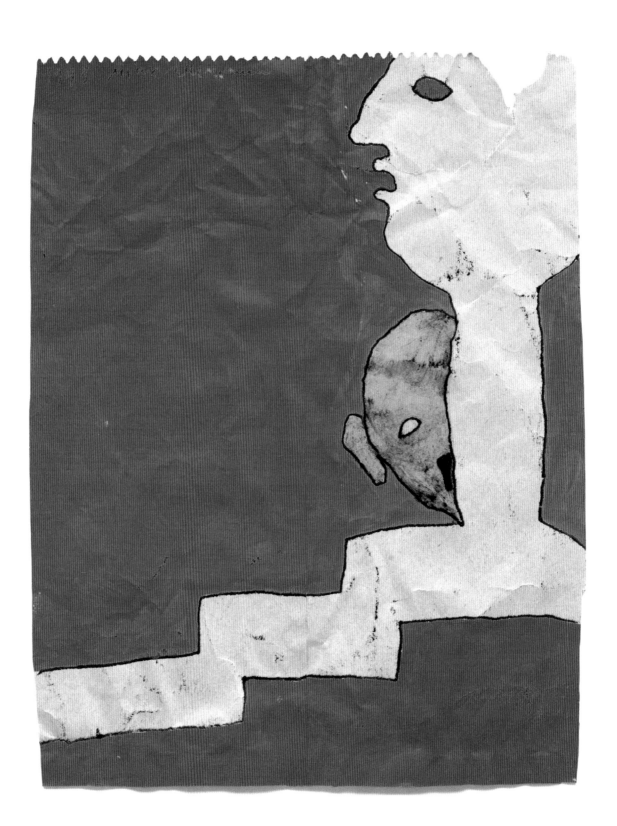

XXXIII

He couldn't bear the prospect of moving on again, even though it would be the last time. The dog had gone ahead, startled by the punishment of its own hearing. Even the inside of the stone was no longer silent, he could hear its slow erosion. He didn't know which direction to take, there were so many tracks he could no longer decipher them. Once he had thought that you could write the world with words: from the beginning. Speaking the words would turn them into things, obedient to their names. That made all languages holy. Now he no longer knew if that was true. The things that surrounded him had closed themselves off more and more as if knowing that they would lose their names again. He wondered what it would be like when nothing was called anything, when everything was just itself. He picked up his suitcase and stood a while longer at the window of his empty house. There was no wind outside. They had stopped flying. He thought of the first word, and then of the last, and imagined that somewhere, sometime, a voice would speak that last word just as that same voice, or a different one, had once spoken the first. All things undone and robbed of their names, words erased until the first word too had never been said. Only then would it be silent again. Only then did it all fall silent again.

The first time I saw Max Neumann was at a sophisticated gathering in Berlin. People stood around and drank and threaded the familiar pearl necklaces with the names and ideas members of a group use to identify each other. There is nothing wrong with such gatherings, they're part of the spice that is part of life, but everyone is familiar with the sudden attacks of emptiness that are just as much a part of it all: the eyes that stop looking at you and drift off over your shoulder, the last sentence you didn't quite catch, the forgotten names, the concealed differences of opinion, the underflow of gossip and the subtle doubt that needs to be drowned out. Amid the tangle of standing people I saw someone sitting, someone who radiated an oceanic calm, someone who was not part of it all. The conversation he was having with the only other seated person seemed of a different order from the hectic buzz around us, a mysterious simplicity hung over him as if he were a different species. That sense of mystery was only confirmed when I first saw his paintings and drawings. I could not reconcile their restlessness with the calm their maker radiated. I felt as if I knew the world I encountered in his work very well without being able to say why. Later I saw his work again in Barcelona and Paris and there too, far from his German base, I again felt the enchantment of those strange, unprecedented creatures, dream figures that resist description. This then was the agreement we made when we decided to do this book together: instead of trying to describe his work, I would draw on its atmosphere and my own arsenal of memories, dreams, fantasies, land-scapes, stories and nightmares to write a series of textual images as an echo but unlinked, a mirror, but independent of the pictures he had given me. If we have succeeded, the title cuts both ways.

Cees Nooteboom
Es Consell, Sant Lluis
Summer 1992/93